Images of Modern America

ABANDONED ASYLUMS OF CONNECTICUT

Front Cover: The Knight Hospital, also known as Mansfield Training School, recreation area may have been used for arts and crafts, as is evident by the amount of art supplies scattered around and paint all over the walls (Courtesy of Tammy Rebello and TMR Visual Arts.)

Upper Back Cover: Outside of the main hospital building at Seaside Sanatorium, taken from the beach in front of it (Courtesy of Tammy Rebello and TMR Visual Arts.)

Lower Back Cover (from left to right): Bryan Building at Norwich State Hospital on the Norwich town property (Courtesy of Tammy Rebello and TMR Visual Arts), Martin Building—male employee building (Courtesy of Tammy Rebello and TMR Visual Arts), the slide of the abandoned, overgrown playground in front of Seaside sanatorium on Long Island Sound (Courtesy of Tammy Rebello and TMR Visual Arts)

Images of Modern America

ABANDONED ASYLUMS OF CONNECTICUT

L.F. Blanchard &
Tammy Rebello

Copyright © 2016 by L.F. Blanchard and Tammy Rebello
ISBN 978-1-4671-2458-4

Published by Arcadia Publishing
Charleston, South Carolina

Printed in the United States of America

Library of Congress Control Number: 2016950039

For all general information, please contact Arcadia Publishing:
Telephone 843-853-2070
Fax 843-853-0044
E-mail sales@arcadiapublishing.com
For customer service and orders:
Toll-Free 1-888-313-2665

Visit us on the Internet at www.arcadiapublishing.com

Lynn dedicates this book to:
To my family, for your love
Tina, for inspiring the light, and continually amazing me
Tam, for standing with me on this incredible journey
Peggy, for being our biggest cheerleader and wonderful
friend (and that Patsy girl too!)
For those who found the courage to share their story
And always, Cathy, for her love and support through every step along the way
Bella, Rocky, and Tango, the cutest, funniest, and
most loved pups (and writing buddies)
All those who shine the light of hope to those lost in the darkness #BeTheLight.

Tammy dedicates this book to:
To my four children, for whom I breathe
My "sisters" Emmie, Jenn, and Michelle—without your friendship
and guidance I would have self-destructed long ago
Lynn, for being my light and inspiration
Cathy, for being my friend and the hardest working roadie around
Kiko, for being part of our lives—forever our sweet boy, forever loved
For all those that suffer from emotionally and verbally abusive relationships, there
is hope! Remember, you are worthy, beautiful and deserve better! The first step
is scary but well worth it in the end. "Live your life while the sun still shines."

Contents

Acknowledgments		6
Introduction		7
1.	Seaside Sanatorium	9
2.	Knight Hospital and Mansfield Training School	33
3.	Fairfield Hills Hospital	49
4.	Norwich State Hospital	61
About the Authors		95

Acknowledgments

We wish to thank Cathy Blanchard, our official roadie; Tina Runyan, PhD, for her constant support, unwavering faith, and inspiration of #BeTheLight; Linda Christensen and the Preston Historical Society; Susan Brosnan and the Preston Library; Sean Nugent and the Preston Redevelopment Agency; Russell Boulet; Mark Veau of WXLO radio; Max Bowen and Matt Zappa from WEMF Citywide Blackout; Kim Caisse and the faculty at our alma mater, Worcester State University; Patricia Graham, of the Myths, Minds, and Medicine Museum at the Institute of Living in Hartford, Connecticut; Mercedes Guy, Kelly Bowen, Valerie Keller, Aline Dick, Dani McGrath, and the entire marketing team for their hard work in promotion our first book, *Abandoned Asylums of Massachusetts*; Erin Vosgien, Henry Clougherty, and the rest of the Arcadia staff, for all of their support, and without whom this project would not have come to fruition.

We would also like to acknowledge all the libraries, bookstores (big and small), the local shops who helped us spread the word and galleries who welcomed us to tell our story, to the radio, television, and newspaper reporters who helped spread the light, to all those who found the strength to share their own stories along the way.

Unless otherwise noted, all images are from Tammy Rebello and TMR Visual Arts.

Introduction

Among the most often asked questions we get is how we got started with this project and what drives us. Tammy and I have known each other for three decades, and while there was a time where we had lost touch, busy in our own lives, we reconnected on Facebook several years ago. Tammy had been photographing for over 20 years at that time, and on a whim, based on the interest her kids took in an episode of *Ghost Adventures*, she grabbed her camera and brother Josh (or as we call him, "the Muscle") and headed out to the New York location.

She loved it the moment she stepped on the grounds and has been hooked ever since. When she returned home to central Massachusetts, she began researching like institutions close by. While exploring, she discovered a strong desire to tell the story of these places. This is when she came to me.

It did not take long before we had a definite direction to our project. Tammy continued photographing, every chance she could, often returning to the locations several times. In the snow or the blistering heat, she persevered with a desire to get just the right shot. We were both students at Worcester State University and had the chance to take a few classes together. This gave us the chance to talk and receive guidance and encouragement from the faculty.

We were recently asked if there was a point when we wanted to throw in the towel and abandon our journey. For me, it came when my mother took ill. During that time, nothing else mattered but spending time with her and the family. The irony of this is it was also the catalyst for me to see it through. While our family came together for her, we would spend hours talking, and it gave me the opportunity to bounce ideas off those I trusted most. After a period of mourning my mother, Tammy and I were ready to move forward and have not looked back.

We quickly discovered how well we worked together. Tammy was in control of everything photographic, and I was in charge of everything written, although we are constantly bouncing ideas off one another. We talk with one another daily, even now that the first two books are finished and out for the world to see. While we do not always agree, we try to maintain our respect for one another. Our friendship is most important—even more than the books. But I feel that is what makes it work.

We approached this project from different angles. Tammy loved the architecture, the style of the buildings, and the artistry of the physical structure set against the rubble left behind. She recently told me how much it saddens her to see these places being torn down. If perhaps these buildings were taken care of instead of left to rot, they could have been saved for future generations to see how beautiful they truly are.

I, on the other hand, come at it from the psychological perspective. I dug in to the history of these locations. I wanted to know for what purpose they were built, what they became, and what led to their demise. I explored the story as a whole, with the perspective of the state, the institution and administrators, employees, patients, and their loved ones and how the mental health field in Massachusetts, Connecticut, and in the United States has each changed over the past century, and why. Tammy and I spoke with dozens of people, all with a unique impression of how the most horrific and unimaginable, alongside the most wonderful, shaped the mental health field today and will continue to as it evolves.

Our goal has always been to tell the story; to let you in, behind the scenes. Perhaps, in our own way, we want start to changing the stigma associated with mental illness. While we have come so far in this field, we still have a battle ahead. For those working to better the lives of others, who teach the tools to a more peaceful state of mind, I commend you. But to those who struggle, you are not alone. Both Tammy and I found the courage to step into the light, and you can too.

One

Seaside Sanatorium

41.3016° N, 72.1296° W

The Story of Thomas

A boy known as Thomas was born in May 1912, amid the hopes and dreams of his mom and dad. In his early years, he seemed to fall behind his peers developmentally and his parents began to suspect something "wasn't right with their boy." The older he got, the more evident it became.

The family doctor confirmed their fear, and told them there were places for "children like Thomas." They were advised to put him away and not look back. While his father, Joseph, agreed to put the boy into a home for the feebleminded, his mother, Mary, did not want to let her child go. She pleaded with Joseph to let Thomas stay with them, but he and the doctor made the decision to have him committed. The doctor tried to reassure Mary that she was young enough and could always have more children.

Within the week, Thomas had been dropped off and his father tried to convince Mary that it was for the best, but she knew better. She continued to try and change his mind, to at least let her see Thomas, but he repeatedly said no, believing that it would just make matters worse. After a few months, Mary had fallen into despair, but thought she would try one more time with her husband. She made his favorite meal and patiently waited at the door when he came home from work. She tried to hide her pain and choose the perfect moment to bring the matter up. She waited until the meal was through and was only able to get out the words, "I want to see Thomas."

Joseph became enraged and struck her. He forbade her from ever mentioning his name again. He told her they should consider Thomas was dead and that he was never coming back. Mary ran out of the house with tears flowing down her face. Joseph hollered for her to return, but she ignored him. That night, Mary disappeared. Her body was found two weeks later, the result of an apparent suicide.

Thomas never saw either of his parents again. He continued to move from asylum to asylum, until he landed in Connecticut, when admitted in October 1920. Reason for his committal was listed as "imbecility." He required assistance when walking or dressing, and he spoke only a few words. The hospital was given $2 a week for his care, as he had become a ward of the state. His father's whereabouts remained unknown.

The design and construction of Seaside Sanatorium began in 1931, and the facility accepted its first patients to the Stephen J. Maher Building in the 1934. It was designed by Cass Gilbert, a

well-known architect of the time, with the main building in the Tudor Revival style.

In 1895, Cass Gilbert earned national attention when he was hired to design the new state capitol in St. Paul, Minnesota. He was credited with the design of the Waterbury City Hall; the US Supreme Court in Washington, DC; Union Station in New Haven; and the Woolworth Building in New York City.

The Seaside, as it was also called, was a unique facility; in fact, it was the first institution of its kind in the United States. It was built on the seashore of Waterford, Connecticut, designed for the treatment of children with tuberculosis. The idea of this was to expose the patients to sunshine and fresh air as part of their treatment. (Courtesy of Russell Boulet.)

This was not only unique to the area, but also nationally significant, as the Seaside was the first medical facility to employ a heliotropic treatment to children with tuberculosis. The waterfront location overlooks Long Island Sound. This property had been acquired by the Connecticut State Tuberculosis Commission in 1930.

The facility went through many names and transformations in its time. It had been called the Seaside Clinic, Seaside Regional Center, Seaside Sanatorium, and the Seaside. From 1930 until 1959, it served as a tuberculosis hospital. Then, for a short time, it was a geriatric center, from 1959 through 1961.

13

Finally, from 1961 until its close in 1996, the facility was a home for those with mental disabilities. Unfortunately, amid allegations of abuse, neglect, and several suspicious deaths, the facility closed.

Though the idea of infectious disease goes back as far as the Neolithic period—approximately 10,200 BC through between 4,500 and 2,000 BC—it is was not until 1865 that the infectious nature of tuberculosis was understood. After another 17 years, in 1882, the tubercle bacillus was discovered, as was the understanding that those infected with tuberculosis must be isolated in order to prevent further contamination.

According to the National Register of Historic Places, "By the mid-nineteenth century the disease accounted for one-quarter of the adult deaths in Europe and by the last decades of the century it had become epidemic in many American cities and was the leading cause of death."

Tuberculosis did not get to the level of epidemic until the Industrial Revolution. With the growth of cities, where more people were in smaller spaces, infectious disease spread rapidly.

Seaside Sanatorium sat on the Connecticut coastline, making it the perfect spot for heliotropic therapy for tuberculosis. Heliotropy is a form of tropism, referring to the motion of plants in response to a stimulus—in this case, the sun. Shown here is the playground in front of the main hospital, where children who were being treated for tuberculosis played in the sun and absorbed vitamin D.

The phenomenon on heliotropism is most noticeable in sunflowers, as evident by the large flowers turning to face the direction of the sun as it moves from the east to the west so they can absorb the most sunlight. In this way, the idea was to expose the patients to direct sunlight to treat the tuberculosis by allowing them to absorb vitamin D.

Heliotherapy, sometimes called phototherapy, is a term most often associated with exposure to natural sunlight; however, more recently, it has also come to include artificial sources of ultraviolet, visible, or infrared light radiation. These artificial light sources are still used today to aid in the treatment of depression and seasonal affective disorder (SAD), which effects people in the long winter months.

The absorption of vitamin D through sunlight is an important factor in healing and maintaining skin health, and sun exposure and other forms of light therapy have also been shown to have positive effects on mood and mental wellbeing. Those in New England still often suffer from low levels of vitamin D, due to the long winter months and shorter daylight hours.

Even to this day, despite the warnings of the danger of too much sun exposure, heliotherapy is used in the treatment of psoriasis and psoriatic arthritis. Plant and animal life are dependent on the sun's natural light.

In the Northeast, vitamin D deficiency is much more common than it is in warmer climates like the tropics. Heliotherapy has been credited with successful uses for the treatment of conditions as minor as acne or body odor to those as extreme as aiding the human immune system for the treatment of AIDS and reducing bacterial infections by up to 50 percent.

With the successful use of sunlight therapy during the World War I, when it was used to heal the wounds of injured soldiers, the civilian world took notice, and several hospitals and clinics were erected in order to accommodate tuberculosis patients. Under close medical supervision, spinal tuberculosis patients were treated using similar methods.

Niels Ryberg Finsen (1860–1904), a Faroese Danish physician and scientist, was one of the forefathers of heliotropic treatments. He invented specially constructed carbon arc lamps that concentrated ultraviolet rays and became known as the Finsen lamps.

Finsen had great success in treating tuberculosis of the skin with ultraviolet light, and he was credited as the first physician to use sunlight in clinical practice as well as the scientific investigations of the treatments effects. Due to his work with these specialized lamps and his theory of how they could be used as a treatment option, he was awarded with the 1903 Nobel Prize in Physiology or Medicine.

By the end of the 19th century and into the beginning of the 20th, heliotherapy had become a commonly used treatment for spinal tuberculosis. This "tuberculosis of the bones" was thought to be caused by low levels of vitamin D, which could be absorbed through sun exposure.

The better-known type of tuberculosis is the respiratory illness that often affects people with a weakened immune system. It can, however, also affect the lungs, kidney, spine, or even the brain. In 1925, some patients were given milk that had been irradiated with ultraviolet rays in an attempt to treat the type of tuberculosis that attacks the bone and joints.

While some research first showed some positive effects of this treatment, it was not enough to lead to significant results. Tuberculosis can be carried in one of two states: the dormant state, in which the patient shows no outward signs of the disease, and the active state, which is contagious, especially to those with a compromised immune system.

According to the National Institutes of Health, tuberculosis is caused by bacteria called mycobacterium tuberculosis. In the dormant state, also known as latent or inactive tuberculosis, patients carry the bacteria of the tuberculosis infection. Because their immune systems are protecting them from this infection, they do not become sick. They show no outward signs of the disease.

This tuberculosis infection is not contagious at this stage, but could turn into an active disease if not treated properly. According to the Centers for Disease Control and Prevention, an estimated two billion people worldwide have latent tuberculosis.

In the active state of pulmonary tuberculosis, the disease can be spread by droplets released into the air when an infected person sneezes, coughs, or talks. Symptoms can include coughing up blood, pain in the lungs or chest when coughing or breathing, unintentional weight loss, fatigue, and chills.

The early stages of active tuberculosis can be difficult to recognize in a patient because the symptoms can occur within a couple weeks or lie in wait for years.

The Centers for Disease Control and Prevention put out a report showing that in 2014, a total of 9,421 new tuberculosis cases were reported just in the United States. During this active stage, the disease is contagious, although experts say it is not easy to catch by casual contact.

Longtime exposure to the infected tuberculosis patient raises the risk of exposure; however, with the proper treatment, patients are no longer contagious after two weeks. Shown here is the main building.

Other parts of the body, besides the lungs, can be infected with tuberculosis, and the symptoms are variable depending on the part of the body effected. For instance, the highly infectious form of tuberculous spondylitis attacks the vertebrae and long bones, crippling the patient. This form of tuberculosis appeared to respond well to prolonged sunlight exposure.

What made Seaside Sanatorium different from many other institutions was its treatment of tuberculosis. Vitamin D has been known to be important to the immune system, promoting good immune proteins and destroying bacteria.

Once there was a successful drug treatment for tuberculosis, the need for facilities such as this, for children and adults, began to wane. The year 1947 brought the use of antibiotics for tuberculosis treatment, and by 1953, a combination of drugs was thought to cure the disease.

Since the late 1800s, exposure to direct sunlight had been a means of treatment in other places, and the Seaside adopted this idea. In the present day, there is a third category for tuberculosis that is the drug- and multidrug-resistant strand. This comes from decades of treatment with antibiotics, and some strands of the disease have self-modified to survive.

Some experiments have shown a possible link to tuberculosis patients having a faster recovery and fewer symptoms when taking vitamin D supplements, though other variables may be involved. As for heliotherapy, while it did not prove to be a significant treatment for tuberculosis, there are more recent studies to suggest it may be beneficial for other ailments.

According to the National Psoriasis Foundation website, "Vitamin D, as well as the UV rays from sunlight exposure, can help clear or prevent psoriasis plaques and boost immunity. The same has been shown with eczema. Overall we see the healing power of sunlight over and over again, showing evidence of reducing inflammation throughout the body."

With the rise of HIV, which is the virus that causes AIDS, in the 1980s, there was a rise in cases of tuberculosis as well. Since AIDS attacks and often destroys the immune system, it leaves these patients susceptible and far more likely to have latent tuberculosis progress into active.

There are differences between a sanatorium and a sanitarium; however, today, the terms are often used interchangeably. Though the difference is subtle, it is still there. Originally, the main difference is that a patient in a sanatorium is always sick (often with tuberculosis), as with Seaside, which was similar to a hospital and designed to treat a specific disease.

A person in a sanitarium might be there for any health-related reason but may or may not be actually sick with a disease. Architecturally, there are subtle differences between an open-air sanatorium for pulmonary tuberculosis and heliotherapy clinics for surgical tuberculosis.

An open-air sanatorium is intended to expose the area to sunlight in order to destroy the bacteria and ease cross-contamination inside the facility. Photographs of patients from the late 19th and early 20th centuries show them in beds and chairs, covered with sheets and blankets. There was no intention of having the patients themselves absorb the bacteria-killing sunlight.

Heliotherapy, on the other hand, intends for the sunlight to be directly absorbed into the patient's skin, boosting levels of vitamin D and reinforcing the human immune system. This may well be where the term a "healthy tan" came from.

Seaside served very briefly as a nursing home in 1958 and then in 1959 as the Department of Mental Retardation, established by Gov. Abraham Ribicoff. Two years later, the department took over the then vacant property of the sanatorium. Seaside remained open until allegations of violent patient abuse became rampant. The hospital also experienced a higher mortality rate than normal.

The Seaside has been vacant since it closed in 1996 and is listed in the National Register of Historic Places. Today, it is in deep decline, a relic once brimming with life now long forgotten and neglected. What skeletons may remain are being torn down to make room for more scenic vistas where families can breathe life back into this forgotten place and bask in the sun and salty sea air.

As of May 2016, Connecticut officials planned to move forward with the first new shoreline park in five decades, on the site of the former Seaside Sanatorium. Though the plan has met with some local resistance, Gov. Dannel P. Malloy assured residents by saying the "beautiful piece of land should be used for the direct benefit and enjoyment of the residents of Waterford and the state of Connecticut."

The developers of this new park hope to achieve the following goals laid out in the master plan document used for resident meetings: to promote and improve the public access to Long Island Sound and restore, preserve, and reuse historic assets where feasible. Shown here is the west side of the main building in 2015.

The plan also calls for the preservation and improvement of the site's ecology and habitat; creation, implementation of, and operating a plan that is financially feasible; and engaging the public in helping to shape the future of Seaside State Park. This 1980s photograph is of the west side of the main building. (Courtesy of Russell Boulet.)

Two

Knight Hospital and Mansfield Training School

41°48'22"N 72°18'16"W

The Story of Gerri Santoro

Born on August 16, 1935, Geraldine "Gerri" Santoro was known to her friends and family as a free-spirited woman who often skipped school. She came from a large family with 14 siblings. She married at the tender age of 18, just a few weeks after meeting Sam Santoro at a bus stop.

Sam was abusive to Gerri, and she feared for the safety of their two daughters. Though he had moved the family to California, with promises that the abuse would stop, his cruelty continued, so Gerri moved back to her family's farm in Coventry, Connecticut, with her two daughters.

Shortly after she returned home in 1963, she got a job at Mansfield State Training School. It was there that she met and soon began an affair with coworker Clyde Dixon, a 43-year-old married man. She became pregnant as a result of this affair.

In 1964, while six-and-a-half-months pregnant, she got word that her ex-husband was coming to visit his daughters. The prospect of seeing him again frightened her. She felt he would likely harm her or her children, which led her to make the decision to terminate the pregnancy. With abortions outlawed at the time, she felt she only had one choice.

On June 8, 1964, armed with a medical textbook and surgical tools Dixon had borrowed from a coworker, the pair checked into a Norwich hotel under assumed names with the intention of aborting the pregnancy. Their plan went horribly wrong, and Gerri began to hemorrhage. Feeling overwhelmed, Dixon abandoned her in the hotel and left her to die. He was later caught and convicted of manslaughter and conspiracy to commit abortion.

Nearly a decade later, the April 1973 issue of *Ms.* magazine published the crime scene photograph of Gerri, nude and on her knees, on the hotel room floor. The headline reads, "Never Again." Never again, the article states, would women die from dangerous abortions as Gerri had. The pro-choice movement later used the same image as an icon on posters and fliers to extol the dangers of "backroom" abortions.

Knight Hospital, also known as Mansfield Training School, was named for Dr. Jonathan Knight (1789–1864), one of the founding professors of the Medical Institution of Yale College. Among other credits to his name, Dr. Knight was a top surgeon and professor at Yale. He is also credited as one of the founders of the General Hospital Society in Connecticut as well as the American Medical Society.

In the fall of 1862, the Knight Hospital building was leased to the US government to be used as a military hospital in the Civil War. In the following three years, from 1862 to 1864, the Knight US Army General Hospital was able to accommodate 1,500 patients in the hospital as well as medical tents set up on the ground. In all, 25,340 patients were treated successfully, while 185 died.

The state-run facility opened in 1860, and even in the time of the Civil War, while the Army leased the hospital building, it continued serving the area in a smaller rented space nearby. In that time, it was known as the Connecticut School for Imbeciles and was intended for the care of those considered mentally retarded.

Serving as occupational therapy and promoting both physical and mental well-being, the farm, established in 1909, was believed to reduce seizures in those with epilepsy. It was also a good source of nutritious food for the school and hospital. As the farming program grew, it became more than a produce farm and included a dairy, pigs, and poultry. It utilized nearly a half acre on the facilities' massive grounds.

Considered an "enlightened" option to the norm of the time, the facility was designed in a "colony" plan that segregated the epileptic patients from others throughout the day. Prior to this, epileptic patients were often locked away at home or in another type of institution. They were considered unable to function in society.

The original plan for this colony began with the superintendent's house. Charles T. Lamoure became superintendent at Mansfield in 1916, replacing the first superintendent, Donald L. Ross. Superintendent Lamoure brought attention to 18 other states that had already successfully combined the care of epileptics and those considered feebleminded.

By 1914, the first dormitories, Binet and Goddard Halls, were finished. These buildings had been designed by Cudworth, Woodworth, and Thompson—who joined their firm the following year—of Norwich, Connecticut. The cafeteria was strategically located between the two dormitories.

In 1915, the name was changed to the Connecticut School for the Feeble-Minded at Lakeville. In 1917, it changed names again when it merged with the Connecticut Colony for Epileptics, which had been established in 1909, and the 350-acre campus became the Mansfield Training School for the Feeble-Minded and was later renamed again to the Mansfield Training School and Hospital, shortly after the end of World War I.

The combination of these two facilities brought together 300 patients from Lakeville and 100 epileptics already at Mansfield, making the need for expansion acutely relevant. By this time, the epileptics were housed with those with developmental disabilities; however, the segregation of the sexes remained.

The facilities followed the same plan as laid out by Norwich State Hospital, with cluster "A" for male patients and cluster "B" for female patients in separate dormitories. Each dormitory held 50 patients. Also constructed that year were the powerhouse and a railroad spur line, which carried construction supplies to the school for further expansion.

By the end of the 1920s, psychiatric hospitals and other institutions around New England were severely overcrowded, and the following decade of the Great Depression made the situation worse. The state's asylums were already beyond maximum capacity, and the waitlist for admissions continued to grow.

Between the Great Depression and World War II, the school had a marked drop in students, which made the overcrowding situation even more dire. Without the staff to oversee the patients, and coupled with the severe economic downturn, the conditions deteriorated quickly.

Still today, the Great Depression (1929–c. 1939) is considered the deepest and longest-lasting economic downturn in the history of the industrialized world. Unemployment was rampant, and people were losing their businesses, their homes, and in many cases, their mental well-being and even their lives.

In October 1929, the stock market crashed, and millions of investors lost their entire life savings. Suicide became rampant as those financiers panicked and could not see past the crash. Consumer spending and investment plummeted as did industrial output, causing a seemingly endless spiral down.

Within four years, there were 13 to 15 million unemployed just in the United States, and close to half of the nation's banks had failed. It was not until at least 1939 that things started to improve for the United States fiscally, when the lead-up to World War II prompted an industrial boom.

The United States was pulled into the war when Japan bombed Pearl Harbor on the morning of December 7, 1941. The following day, the country officially declared war on Japan, and within the week, Nazi Germany and the other Axis nations had declared war on the United States.

At home, the war effort became the highest priority, and many of the employees of these mental institutions either left to fight in the war or to lend their hand to support the Allies. This left many of the nation's mental health facilities largely in the hands of the patients.

The end of the war came into sight in the spring of 1945. Seeing the inevitable, Adolf Hitler, the leader of Nazi Germany, committed suicide on April 30, 1945. Later that year, the United States dropped an atomic bomb on Hiroshima on August 6 and another on Nagasaki on August 9. Though Japan had agreed to the idea of unconditional surrender, it held off until August 14 to officially surrender, ending World War II.

After the Great Depression and the war ended, students returned to the school and the population of patients leveled out. From 1950 through 1970, the facility saw significant growth. There were several dormitories, and many of the older buildings were brought up to code. By 1969, a total of 1,609 residents and 875 full-time staff were in residence.

The new expansion plan, including new construction—while adding much needed housing for patients and employees, as well as support buildings—had little effect on the historical heart of the school because structures were built away from the historically relevant area, with the exception of the administration building.

The main building had an entrance just off Route 44, and was built around the same time as other wood-frame structures, including a home for deaf patients. Mansfield Training School and Hospital reached its peak with over 50 buildings and 1,800 patients. By 1991, the number of residents had dropped to 141.

On December 6, 1978, Peg Dignoti and Bob Perske of the Connecticut Association for Retarded Citizens, now the Arc of Connecticut, filed a class-action lawsuit in order to shut Mansfield Training School and Hospital down and relocate the remaining patients to a more humane location. The group felt these patients should not be locked away from the community, but should be a part of it.

In this suit, referred to as *Connecticut Association of Retarded Citizens (CARC) v. Thorne*, the plaintiffs claimed there was a negative bias by state authorities against those perceived to suffer from developmental disabilities. They offered three complaints: the state saw some of these persons as burdens in their own neighborhoods, saw them as needing programs the community could not provide, and sent them away to live at Mansfield Training School.

In a speech by Robert Perske at the closing of Mansfield Training School and Hospital on Saturday, April 24, 1993, he explained the demographic of those who had been represented in the class-action lawsuit. Perske explained that there were "14 named plaintiffs, 859 persons residing at Mansfield, 839 persons Mansfield sent to nursing homes, and numerous persons still at risk of being sent to the institution."

```
                                    Signed_____Superintendent
                                           George Moore
                                    of the Central Connecticut Regional Center

te November 1, 1983
            KINDLY GIVE COMPLETE INFORMATION FOR EACH ITEM

Name of Resident   Maria
Date of Birth     4/24/55          3) Sex    F     4) Mental Level    5
Name of Parent or Guardian        No interested relative
      Not Adjudicated      (note legal status if client is over 18)
Address of Parent or Guardian_____
Transfer is made with agreement of Parent or Guardian  N/A  Yes _____ No
Transfer is made with agreement of client   X  Yes         No.
If answer is no, give explanation:_____

                  INSTRUCTIONS PERTAINING TO TRANSFER
All records must accompany the resident upon transfer.
A copy of this transfer form must be transmitted to the Commissioner, De-
partment of Mental Retardation.
```

In speaking of the many horrors the patients had been subjected to, Perske mentioned photographs that had been taken by the Department of Justice, and they were used in the court battle. He explained the conditions at Mansfield and why he and the others worked so hard to get it closed.

> Nov. 5, 1955: Obese, smiling idiot. Screams loudly without cause. Large head. Rips clothes of self or others. Digs and scratches, hits pushes, pulls hair when disturbed. Walks too well. Feeds self with spoon and steals from other trays. Understands. Is toilet trained. Watches Tv. Likes to be read to, laughs and laughs. Cannot dress but is fussy what she wears. Like to imagine she is going away and will then cooperate. Serpasil 0.25 mg at 7 & 5, which she likes to take, is no better on same. Changes to thorajine mg 25 tid. Wallace Hall

According to Perske, "Some [of the photographs presented] showed as many as 20 adults in diapers lying together on one vinyl covered mat. Some showed twisted legs and arms due to the lack of physical therapy. Other photos showed people shackled to wooden chairs with leg, arm and waist restraints. There were people sitting in long lines in day rooms."

Perske continued describing the what he saw in the pictures: "Some stared endlessly into spaced. Some slumped over in sleep. Others slept on the floor. Photographs showed gang showers and rows of toilets with no partitions. Some toilets had no seats. I will never forget one photo showing a little child sleeping under a stainless steel bathing slab—the same kind one usually finds in a funeral home."

In the findings of the presiding judge in the class-action suit, Judge F. Owen Egan states "that the institutional environment was destructive. That there were environments 'devoid of potential for meaningful human activity.' That physical restraints were used to control clients as a substitute for programs. That many residents were denied their privacy and basic human dignity."

On the day of the school's closing, Perske said, "Today the battle ends. Mansfield Training School is closed." But the celebration is even greater for those who advocated for these forgotten souls, as those who once were oppressed now stand up for themselves alongside their allies to be a voice for others who had formerly been deemed unworthy.

Three

FAIRFIELD HILLS HOSPITAL

41°24'N 73°14'W

THE STORY OF THE LOBOTOMY

Fairfield Hills State Hospital, also called Fairfield Hills and designed by architect Walter P. Crabtree, was located in Newtown, Connecticut. The main campus of 16 buildings sat on 100 acres of land and lent itself to a "campus-like" feel. A network of circular roads linked the buildings as well as an underground network of tunnels, used for travel between the buildings in poor weather.

It was the state's third psychiatric hospital, owned and operated by the State of Connecticut Department of Mental Health. Built in an effort to ease overcrowding, it opened in 1931.

A lobotomy is a general category of several different operations intended to damage brain tissue with the intent to treat different types of mental illness. Despite its controversial reputation as barbarism, they were widely used for decades.

The procedure, which has also been referred to as a leucotomy, or leukotomy, is a neurological operation intended to sever the connections in the brain's prefrontal lobe. The thinking of the time was that doctors could fix the neurological connections between the frontal lobe and the rest of the brain, stopping the undesirable behaviors.

Lobotomies were commonly used for the treatment of schizophrenia, manic depression, panic disorder, mania, and bipolar disorder. Unfortunately, these operations came at a high cost, with adverse side effects such as incontinence, vomiting, eating disorders, lethargy, apathy, epilepsy, loss of motor function, loss of cognitive abilities, paralysis, blunting of personality and emotion, and death.

The prefrontal lobotomy was developed in 1935 by Portuguese neurologist António Egas Moniz. In 1949, he was awarded the Nobel Prize in Physiology or Medicine, which caused the family and friends of those on whom he performed the procedure to protest and call for the prize to be rescinded. The perceived barbarism of the procedure spurred the expostulation, and the histories of many of his patients show they suffered permanent brain damage and marked changes to their personalities, but the remonstrators' request was denied.

Prior to the release of antipsychotic and antidepressant medications, lobotomies were used to treat different types of mental illness. These were considered viable options for treatment. The asylums of that time were more of a method of containment than treatment.

Patients held in these facilities were often mistreated and/or neglected. Overcrowding, extremely high patient-to-employee ratio, and lack of understanding and training contributed to the deplorable conditions.

While the use of lobotomies has not completely ceased, they are now very rare. If they are performed, it is as a last resort to all other methods of treatment.

In 1929, twelve trusties were appointed to establish and oversee the purchase of an 800-acre site, construction, and subsequent management of Fairfield State Hospital in Fairfield County, Connecticut. This came to be as the need for a third state facility was realized in the early 1920s.

On June 21, 1933, a total of 32 men, the first set of patients, arrived at Fairfield Hills in Newtown. They had been transferred from Connecticut State Hospital, which had been struggling with overcrowding. At this time, patients requiring care in a mental health facility were assigned by the location of their residence prior to committal. For instance, each of the 32 men had given either Fairfield or Litchfield County as the site of his most recent residence.

Staffing became a priority. While many positions could be filled by those in town, many jobs went to patients. It was thought to be therapeutic for them to fill such jobs as laundry, grounds keeping, farming, food preparations, and maintenance. Later, when women started to be transferred in, they would mend clothes, under the supervision of a seamstress, or practice basket weaving.

The other two state-run facilities in Connecticut were still overloaded with patients requiring special care, including those considered untidy and/or destructive. The Connecticut commissioner of finance and control consulted Dr. Roy L. Leak, the first superintendent of Fairfield Hills, about adding 500 more beds to the facility.

The problem with adding more beds to the facility, as Dr. Leak rebutted, is that it would only be possible if they were to use every available space for housing, including exam rooms, porches, the dining room, and dayrooms. He also mentioned the extended need for a larger, qualified nursing staff to care for these extra patients.

By November 1935, the board of trustees had decided to transfer another 383 patients. On November 15, 1935, Dr. Clifford D. Moore was appointed the new superintendent of Fairfield Hills State Hospital. New structures were built to ease overcrowding in the Shelton and Greenwich Houses. Both Kent House and Canaan House were dedicated in 1940.

While the staff at Fairfield Hills struggled to care for their ever-expanding population, several modes of treatment were being used. In the autumn of 1936, hydrotherapy was introduced at Fairfield Hills as a therapeutic means to calm the patients.

Hydrotherapy was thought to aid in alleviating some of the symptoms and perhaps even the causes of the patient's mental anguish. It was so prevalent, in fact, that by January 1937, the staff administered more than 850 continuous baths and wet-sheet packs.

Hydrotherapy is still used today as a mode of exercise that is much easier on the joints and the backs of patients. It is most commonly used to treat conditions such as arthritis or partial paralysis. As the water is often heated, it adds an additional layer of comfort for those afflicted and allows them to move more freely than they could otherwise.

Overcrowding continued to be a burden. Though a request had been made for funding to construct new buildings, it took more than two years before the legislature approved a $2 million budget. This was intended to include housing for 2,000 more patients as well as farm buildings, including a piggery and a slaughterhouse.

The third unit of Fairfield Hills State Hospital was dedicated on September 12, 1940, by former governor Wilbur Cross. In his dedication, he said, "The future advance in the cure of many mental disorders lies in the prevention of their development."

Amid the worldwide turmoil of the 1940s, as well as rampant understaffing, many of the state hospital's employees began to show signs of alcohol abuse. A suspicious death of a patient on November 1941 prompted an autopsy that determined the patient had been beaten to death. Following the investigation, five employees were fired and one was sent to jail.

Dr. Clifford Moore, the facility's superintendent, was concerned for the public image of the hospital after the patient's death. The reputation of the facility worsened with reports of tension between employees and the administration, patients dying from attacks from other patients, and patient suicides. However, even though violence, abuse, and neglect had become more common, the community in town was more concerned with patient escapes.

With influenza and bronchopneumonia plaguing the hospital, 41 mostly elderly patients died in December 1944. The hospital was forced to close its doors to the public for nearly two years. During that time, tuberculosis patients were treated in two wards of the Greenwich House. When it was reopened in 1946, the Fairfield House served as the tuberculosis isolation ward where, for the first time, female patient wards outnumbered those for males.

By the early 1940s, electric shock therapy became a common avenue of treatment, especially for the clinically depressed patients. These treatments continued into the 1950s, and by 1953, there were close to 275 patients receiving the therapy three times a week.

Chuck Hall, a psychiatric aid at Fairfield Hills at the time, wrote about the abuses he witnessed while working there. His 1954 report exposes neglect and brutality that he claimed to have brought to the attention of his superiors, including the superintendent.

However, no action was taken, except for Hall being fired. He was reinstated a few days later, but with a warning from Superintendent Green, which was, according to Hall, "Although I have to reinstate you, I will be looking for reasons to fire you." In response, Hall published a small book about his experiences.

Named in honor of a former chairperson of the board of trustees, Alice Cochran, the last treatment building, the Cochran House, opened in 1956. This building stood out from the rest of the facility for a couple of reasons: it was the only building that had been named for a person, and its main entrance faced Mile High Hill Road rather than being included in the circular plan for the campus.

The Cochran House at Fairfield Hills Hospital earned the moniker "Snob Hill," as it boasted the most modern 12 wards on campus. It featured a "dignified" entry, small ward units with a high degree of individual care, an open ward design on the first floor, updated treatment services, and an impressive medical library complete with a full-time staff. Patients were encouraged to take charge of the building's housekeeping and welcoming new patients as part of a patient government instituted to give patients control and sense of purpose. It was also financially beneficial to the hospital, as it reduced the number of paid employees.

Cochran's first-floor open ward is also the first incident of a patient government. Patients elected officers and took responsibility for introducing new patients to the ward as well as housekeeping.

Four

Norwich State Hospital

41.4897° N, 72.0727° W

The Story of Donna

Donna had been working as a nurse in the mental health field for almost seven years and bounced from one hospital to another. She had a certain disdain for her work, and it was evident with the way she treated those entrusted to her care. She had been dismissed from one hospital for striking a patient while shouting profanities at him. The system failed in proper recording of her indiscretions, and she was free to move to another facility without repercussions.

Another dismissal had come after she had several instances of neglecting incontinent patients sitting in their own waste for hours, often until the next shift came in. After several reports filed by other employees and family members of these patients, she had been suspended. This pattern of abuse and a suspension happened several times; each time, Donna returned to her position within a week without further repercussions. She had worked at that facility for over four years and had been written up for a dozen infractions. Finally, on an overnight shift, she was found curled up in a reclining chair, covered in a blanket, sound asleep. The morning supervisor reported that she observed Donna for several minutes before waking her. When confronted, Donna's response was, "Whatever, they're fine." She was fired on the spot and did not attempt to return to that hospital.

One more time, Donna found employment in the mental health field. She was once again on the night shift, unsupervised on an understaffed shift. Those that worked with her had complained that she had not been pulling her weight and that she had disappeared for hours at a time. Her coworkers, once again annoyed by her mysterious absence, decided to find her one night. She was found in a storage room with two patients, a man and a woman, with intellectual disabilities. The pair was naked and in the midst of intercourse, both of them crying as Donna laughed.

The others rushed in and put a stop to it, covered the patients with blankets, and did their best to comfort them. It was later revealed that it was something Donna had been doing for several years at other institutions. She said it was entertaining. She was suspended while the allegations were under investigation and later fired. Charges were brought against her and in light of her dismissal, Donna filed suit against the hospital for wrongful termination. Thankfully, not only did she lose that suit, but she was convicted of the neglect and abuse of those under her care.

Norwich State Hospital for the Insane opened in October 1904 on 70 acres of land in Preston, Connecticut. Under Henry M. Pollock, MD, as the superintendent, it started with an initial 95 patients. Shown here is the administration building.

By 1905, the facility saw an unencumbered rate of growth in the number of residents. Just over a year after opening, there were 151 patients, and the facility had two new buildings. The main entrance of the building shown here was the original hospital, but after this expansion, it became the administration offices.

Also in 1905, Norwich State Hospital established a training school for nurses. Another building, the third on the campus for patient housing, was opened in 1907. By 1913, the patient population had grown to nearly 1,000, and 13 more buildings were erected.

These new buildings were not all intended for patient use. As the facility grew, so did the need for a larger staff, and several of those new structures were for the doctors and nurses. The hospital also opened a laboratory and kitchen and dining area for the staff as well as an employee club.

The hospital was a self-sustaining community complete with a barn, piggery, chickens, vegetable gardens, a police department, fire department, power station, theater, greenhouse, two garages, and a paint shop.

While rumors of castration and sterilization of those deemed either mentally deficient or mentally ill have existed since before the turn of the century, it is more popularly known to have begun into the first years of the 20th century. Connecticut was the first state in New England and the second state in the country to pass a sterilization law.

The Indiana Plan was used as the model for a law that issued in a eugenics movement that would maim thousands, many without their consent or even knowledge. The Connecticut version of the eugenic law was introduced in February 1909 by Rep. Wilbur F. Tomlinson, and it passed that August.

This new law concerned "operations for the prevention of procreation" and legalized the sterilization of "certain patients" in the state asylums in Middletown and Norwich. The law allowed hospital staff to take not only the individual but also the patient's family into account in deciding if the family line was unfit to continue.

Both genders were sterilized—by vasectomy and ovariectomy (later called an oophorectomy), performed at the discretion of the hospital staff, though the number of these sterilizations was often based on how the superintendent at the time felt about such barbarism.

The 1909 law states, "Such board shall examine the physical and mental condition of such persons and their record and family history, so far as the same can be ascertained, and if, in the judgment of a majority of said board, procreation by any such person would produce children with an inherited tendency to crime, insanity, feeble-mindedness, idiocy, or imbecility."

The 1909 law goes on to say, "There is no probability that the condition of any such person so examined will improve to such an extent as to render procreation by any such person advisable, or if the physical or mental condition of any such person will be substantially improved thereby, then said board shall appoint one of its members to perform the operation of vasectomy or oöphorectomy, as the case may be, upon such person."

This practice of eugenics continued until July 1, 1965, when then-governor John N. Dempsey (serving from January 21, 1961, through January 6, 1971) signed a bill that allowed "competent" patients to decide if they wanted to be sterilized.

Before operating, the patient's legal guardian had to give written consent, or if there was no guardian, the permission came from the hospital's board of trustees. There were two categories patients had been put into—the first, those considered to be mentally ill; and the second, those considered mentally deficient.

In these terms, the mentally deficient were those below a certain IQ, whereas those who were deemed mentally ill were those suffering from anything from schizophrenia to depression or even what they called hysteria. When it came to sterilization, Connecticut performed far more on those considered mentally ill rather than mentally deficient, as was the trend in New England at the time.

During the time of this law, which accounts for five decades, 557 individuals were reported to have been sterilized. Of those, 92 percent were women, 74 percent were mentally ill, 26 percent had been deemed "mentally deficient," and 86 percent were mentally deficient or intellectually disabled women.

As early as 1918, Norwich State Hospital for the Insane soon became home to more than 700 violent and dangerous patients. The hospital held the worst of the criminally insane population in Connecticut, including child murderers, rapists, and other vicious offenders.

A pattern of suspicious deaths began to occur, with some related to released or escaped patients and others to those who remained under the care of the facility. In December 1914, a patient named Edward K. Arvine was found hanging from the iron grating by sheets torn from his bed.

In 1917, Franklin Wilcox, MD, was named as the new superintendent of Norwich State Hospital for the Insane. A year later, the population had grown to 1,231, and the hospital was reeling from yet another violent death when patient Solomon Brooks escaped and murdered his wife, Rachel Brooks, that September.

In 1919, there were two more tragic deaths when a hot water heater exploded. Teamster Fredd Ladd and night attendant Thomas Duggan were killed. By 1920, the patient population had grown to 1,341.

By the late 1930s, the hospital was 18 percent over capacity. By 1939, the patient population had grown to 2,918. Then-governor Raymond E. Baldwin teamed with the state legislature to form

an investigatory commission to monitor the conditions for institutions caring for those with both physical and mental special needs.

The primary focus of the Commission on the Treatment and Care of People Afflicted with Physical or Mental Disabilities was to investigate the conditions at Norwich State Hospital. Also at this time, Norwich had been rejected by the American Medical Association due to its failure in meeting the minimum requirements of the American Psychiatric Association.

In 1925, the hospital's cook, Fred Smith, was killed when he was struck by a car driven by Robert Anderson, a supervisor at a nearby tuberculosis sanatorium. The following year, the hospital changed its name from Norwich State Hospital for the Insane to simply Norwich State Hospital.

By the end of the 1920s, Connecticut had opened three state hospitals, and the need for more beds had risen significantly since the first was opened in 1866 in Middleton. The second was Norwich, with Elijah S. Burdsall, MD, as the new superintendent in 1928; and the third, Fairfield Hospital in 1929. There were with 6,000 patients between them. (Courtesy of the Preston Historical Society.)

Norwich State Hospital faced more problems in 1930. The population had risen to 2,422, but the training school for nurses was forced to close due to a failure to meet the standards of the State Board of Nurse Examiners. There was another suspicious death; this time, it was Anne Prudential by suicide. She had been a trained nurse and later became a patient at Norwich. She stabbed herself only days after discharge.

The suspicious deaths continued, this time with a murder-suicide, when Sheriff Michael Carroll was shot to death by Leonard Gosselin, who then turned the gun on himself. Gosselin was meant to be committed that cold December day in 1934. This was the same year the hospital got another new superintendent, Chester A. Waterman, MD.

The buildings at that time were marked with a single letter (as in building A), and either "north" (for female patients) or "south" (for male patients). As with other similar facilities, Norwich suffered from overcrowding, and by the time the Depression hit in 1929, the hospital was left to contend with an overabundance of residents and a long waiting list for admission.

This was in reaction to its inability to attract capable employees who were willing to stay long term. Those employees it did have were vastly overworked, as understaffing had hit its zenith. Problems like these caused the creation of House Bill 1650.

House Bill 1650 established that there would be a five-person commission, which was also referred to as the Barker Commission, whose responsibility was to investigate the challenges of those with either physical or mental disabilities in Connecticut. The commission was also tasked with investigations into allegations of neglect and abuse.

The Barker Commission covered financial usage as well as the efficiency of the hospitals and the Connecticut mental health system itself. Items the commission would have looked into may have been the misuse of and false records on the funds intended for feeding the patients, as such fallacies were discovered later. (Courtesy of the Preston Historical Society.)

The Barker Commission later became better known as the Commission on the Prevention and Care of Sickness. Investigating the administration of Norwich State Hospital was its first priority. As directed by Gov. Raymond E. Baldwin, the commission focused on allegations of abuse and neglect, as well as a rash of suspicious deaths.

The death rate had been much higher at Norwich than other institutions. There were serious charges made in the completed report that was filed in November 1939. The commission's next task, as directed in House Bill 1650, was to focus on proposing legislature and budgets for these facilities.

The Barker Commission was also instructed by House Bill 1650 to dig into records; investigate claims of abuse, neglect, and other allegations of cruelty; and issue subpoenas when needed. These investigations were set to be handed to Governor Baldwin by January 1, 1941.

Due to the investigations of the Barker Commission (mentioned on the previous page), the legislature was made aware of the numerous problems within the mental health field. This raised questions as to the history of abuses and neglect, basically identifying the problem, and then working toward solutions to said problems.

The ever-growing need for quality care facilities, changes in laws governing committal, and a tragic lack of communication between existing agencies as well as an emerging focus on the need for treatment programs for alcoholics and addicts exposed the trouble with an attempt at reform for the existing system of care and the addition of the need for those suffering from substance abuse. It overwhelmed the system.

In 1940. William A. Bryan, MD, became superintendent. During his tenure the campus buildings were having their letter names and gender identifications replaced. The new names were in honor of some of the pioneers of the mental health field as well as some of the first superintendents.

The year 1941 brought another suspicious death to Norwich State Hospital. Patient William Smith died when he was accidentally given a sedative rather than his medication for his chronic heart condition. The year was also the first time that the hospital had more discharges than admissions, with 917 discharges and 626 admissions.

In the early to mid-1940s, Connecticut hospitals were under investigation for overuse of restraints with patients. Norwich was cited with 16 patients in restraint and 32 in seclusion in 1942. The investigators advised that "the use of such measures be materially decreased." (Courtesy of the Preston Historical Society.)

Despite this hope, in one month in 1945, it was reported that 26 patients in this same hospital spent 6,552 hours in various types of restraint and 80 more spent 13,900 hours in solitary seclusion. Restraints and seclusion were intended to be used sparingly and only under doctor's written order.

The numbers previously mentioned account for the reported cases of restraint use; however, other types of restraint, such as patients who were held in bed or a chair with a towel for days and weeks at a time, went unreported. There were indeed reports of patients being restrained much longer without a doctor seeing them because doctors did not like to visit the wards due to deplorable conditions and unruly patients. (Courtesy of the Preston Historical Society.)

These so-called "sheet restraints" were used in different ways. At the time, they were used as a full-body restraint in the bed or chair, where the sheet would go over the torso, or legs, and tie behind the patient. Other times, they were used much like cuffs or the leather restraints to immobilize the hands, ankles, and even the patient's neck or head.

As a result of patients being restrained for extended periods of time, they would often develop preventable physical maladies due to insufficient supervision. Edema in the extremities and sores at both the site of the restraint and/or other parts of the body—like the buttock, legs, or back—were common in these times.

Another means of restriction was chemical restraint. Medications like sodium phenobarbital, a barbiturate, was given every few hours to keep patients "under control." As with these other means of restraint, they were meant to be prescribed by physicians and administered by the doctors or registered nurses.

However, at the time, the responsibilities of restraining were too often left to the discretion of untrained aides, even leading to the death of the patient. In 1948, Ronald H. Kettle, MD, became superintendent. Then, on October 1, 1953, the hospital was administratively transferred to the Department of Mental Health.

In 1955, Norwich State Hospital hit its peak patient population, with 3,184 patients. Most of the patients at the time were considered to be suffering from "mild psychoses." This would include patients with depression, hysteria, and anxiety. The tuberculosis ward was segregated, as was the ward for those suffering from schizophrenia.

By 1959, the population at Norwich stood at over 3,000 patients. The urban location of Norwich State Hospital allowed for the medical treatment of these patients, as opposed to the mere containment—and often abuse—of patients in other New England states.

In 1960, the population had declined to 2,685, but the facility added the largest building on campus. The new medical building, named the Ronald H. Kettle Center, opened with the idea of biologically treating mental illness on a short-term stay. Biopsychiatry, as it is also called today, deals with the biological function of mental disorders on the nervous system. (Courtesy of the Preston Historical Society.)

In 1961, Norwich State Hospital became Norwich Hospital. The Ribicoff Research Center was also constructed, directly adjacent to the Kettle Center, with the hope of new discoveries for the treatment of mental disorders. Today, the center still works toward a better understanding of several types of mental disorders.

The Ribicoff Research Center is now known as the Connecticut Mental Health Center Abraham Ribicoff Research Facilities. According to its website, in addition to research, the facilities have worked in a cooperative partnership between Yale University and the State of Connecticut to "further our understanding and treatment of schizophrenia, depression, mania, development disorders, anxiety, stress, and drug and alcohol addiction."

After the release of medications used for the treatment of various mental illnesses and the growing trend of deinstitutionalization, the numbers of both patients and employees had dropped. Though there was still some construction of new buildings, it was more often done to replace an older building rather than expansion. By the early 1970s, only seven structures were being used for housing; the rest were either abandoned or used for storage.

Further trouble and tragedy came to Norwich State Hospital in 1971. A patient named Robert Lane escaped from the maximum-security section of the hospital and killed two officers from the Spencer, Massachusetts, police department. This marked the end of the prison-like maximum security facility at Norwich, as the building was closed in October of that year and all the patients were transferred to the newer Connecticut Valley Hospital.

Though the so-called infamous Salmon Building previously used to house the criminally insane had been described as "disgraceful, ancient and inadequate" and had closed, trouble for the hospital itself continued. In the summer of 1975, another former patient, who had been released eight months prior, murdered Leonard Flannery.

On May 13, 2016, the Town of Preston and the Mohegan Tribe signed a memorandum of understanding, which outlined what comes next in negotiations in the purchase of the former campus of Norwich State Hospital. While the tribe and town officials had been trying to get something to work for more than a decade, representatives from the Mohegans felt the environmental cleanup had reached a point where they can attract partners for development.

In a Preston town meeting, representatives from the Mohegan Tribe presented a preliminary plan to the residents for the property of the former Norwich Hospital. With the proposed construction, this development could mean a major boost to the town and state economy, as well as creating an estimated 200 to 700 permanent jobs.

The number of possible permanent jobs does not include the hundreds of temporary workers for construction of the development. This project could cost as much as $200 to $400 million. To date, there has been nearly $30 million spent on cleanup, demolition, and remediation. Provided this deal goes through, the state could spend another $10 million to finish the abatement before the deal is finalized.

According to the preliminary agreement with the leaders of the Mohegan development and the town officials, there are several options for the vast area. Among the possibilities is that the property could host a slew of family entertainment options, with recreation spots, retail stores, a hotel, senior housing, and timeshares. This property is directly across the Thames River from Mohegan Sun.

The nearly 350 residents of Preston, Connecticut, who were in attendance enthusiastically voted for the plan to move forward in a matter of minutes. Beyond the creation of jobs, this project has the potential to usher in a boom for the economy of both the town and state with the tax revenue, not to mention for other businesses in the area.

First Selectman Robert Congdon said in the wake of the astonishing positive vote, "There was overwhelming support to see something good done here with our partners across the river." Other developmental concepts for the land include a year-round synthetic ski slope, an outdoor adventure game park, and glamour camping. Both parties have agreed that the priority is to attract new companies to southeastern Connecticut to help boost the economy.

Mohegan tribal chairman Kevin Brown was encouraged by the expediency of the vote. He said, "This is a win all the way around. It helps the state, this helps the town of Preston, this helps us continue our development." From the time of the vote through the following six months, which ends close to end of 2016, the Mohegan Tribe will further develop its plan for the 393-acre property.

During this time, the Preston Redevelopment Agency, represented by chairman Sean Nugent, agreed to work with the Mohegans on a purchase agreement. Chairman Brown said the next step will be to find a "master developer" for the property. The town and its officials have given the parties exclusivity for these six months so they have time to assess the property.

As laid out in the memorandum, the Mohegan Tribe will set aside $11 million for the purchase of the 939-acre lot, as well as another $600,000 to assist in legal fees. Once the Preston Board of Selectmen and Finance approves the proposed plan presented on behalf of the Mohegan Tribe, it will go to another town vote. Provided the town votes to move ahead, the development would begin within three years of the transfer of the property. The property should be fully developed within five years, unless both parties come to an understanding.

When asked what would happen if the deal fell through and the land was not developed, Selectman Congdon said, "We would get tax revenue on the land and receive $11 million. We would pay all of our debts and wind up with about $5 million in the bank. None of us want that. We want long-term development that creates tax revenue going forward."

About the Authors

L.F. Blanchard (left) was born and raised in Worcester, Massachusetts, where she is an award-winning artist and writer. While she has been writing most of her life, she only recently found her place in the art world. Her mother was a self-taught portrait artist and was one of L.F.'s biggest cheerleaders. Encouraged to take an art class, L.F. stepped into that world and has not looked back. She enjoys the challenge of undertaking several different forms of art but has a special affection for sculpting and acrylics.

L.F. earned a bachelor of science in psychology from Worcester State University, with minors in communications and art. She is currently working toward a master's degree in art therapy at Springfield College in Springfield, Massachusetts. She has a long history as a peer counselor and several decades teaching personal safety and self-defense. On her days off, she enjoys traveling around the country, with special interest in the spectacular national parks as well as anything that gets her close to nature.

Her artwork, photography, and information on upcoming shows and projects can be found on her website, www.LFBlanchard.com, as well as her Facebook page, LFBlanchard.

Tammy Rebello is an award-winning photographer from Oxford, Massachusetts. As a young mother, she put her life on hold to care for her children. As her children grew older, Rebello decided to return to the academic world. After four long years and many late nights, she graduated in 2015 from Worcester State University with a BA in communications.

When it comes to photography, Tammy likes to take create a record of historic architecture and abandoned locations. She finds it important to document these locations in order for the current generations to understand the past and how it affected the people who lived through those times.

In her spare time, Tammy enjoys traveling, knocking things off of her bucket list, and, most importantly, spending time with her four children Amanda, Emalee, Austin, and Errick—the loves of her life. More information about Tammy and her work can be found at www.tammyrebello.wix.com/tmrvisualarts, or www.facebook.com/abandonedne.

To find out more about the authors and their other books, future projects, book signings, articles, and interviews, please visit abandonedma.wix.com/abandonedma or on Facebook, at abandonedne.

DISCOVER THOUSANDS OF LOCAL HISTORY BOOKS
FEATURING MILLIONS OF VINTAGE IMAGES

Arcadia Publishing, the leading local history publisher in the United States, is committed to making history accessible and meaningful through publishing books that celebrate and preserve the heritage of America's people and places.

Find more books like this at
www.arcadiapublishing.com

Search for your hometown history, your old stomping grounds, and even your favorite sports team.

Consistent with our mission to preserve history on a local level, this book was printed in South Carolina on American-made paper and manufactured entirely in the United States. Products carrying the accredited Forest Stewardship Council (FSC) label are printed on 100 percent FSC-certified paper.

MADE IN THE USA